The Vinson Collection of
INDONESIAN
TEXTILES

CONTENTS

About the Collection

The distinctions between "fine art," "folk art" and "handicraft" are not always clear in East and Southern Asia. While ceramics and other objects made for the Chinese emperor have long been highly prized and admired in Asia for their extraordinary beauty and technical proficiency, objects made for other courts, or for local ceremonial or religious uses, have not always been so widely appreciated. South and Southeast Asian textiles have historically been one such underappreciated group of beautiful objects requiring incredible skill, knowledge and time to create. They were occasionally acquired by the Dutch in Indonesia during the periods of spice trading dominance (starting in the late 16th century) as souvenirs, handicrafts and collectibles. However, in this period collectors rarely documented carefully the contemporaneous design, making and use of very early Javanese batiks and some ceremonial weavings, particularly in Sumatra and Sulawesi. Indeed, one must note that it was Sir Stamford Raffles as Lieutenant Governor of the Dutch East Indies during the period of British occupation (1811-1816) accompanying the Napoleonic Wars, who carried out the first serious study of Javanese history and culture. His 1817 publication, *The History of Java*, brought batiks to popular notice. Ironically, the 1836 Dutch translation of this book omitted the chapter "Antiquities of Java" because the translator considered antiquities to be "subjects of entertainment and diversion" and therefore to be "unnecessary." For a fuller account of this period, see Itie van Hout, *Indonesian Textiles at the Tropenmuseum* (2017) at 44; Inger McCabe Elliott, *Batik: Fabled Cloth of Java* (1984) at 38.

Subsequently, during the period of official Dutch colonial hegemony (1816-1949), textiles, particularly from the primary trading islands of Sumatra, Borneo, Java, Sulawesi, Bali and some of the Eastern Islands, were collected more systematically to build collections and to archive historical and anthropological knowledge of Indonesian art and culture. Important studies of Indonesian weaving and batik technique, design and cultural significance began to appear at the end of the 19th century. Finally, following Indonesian independence in the late 1940's, the appreciation of these objects as art more than handicraft has expanded, and important collections have continued to be assembled as much by collectors of beautiful objects as by anthropologists and ethnographers.

Application of wax for a batik, using a canting.
Licensed from Alamy, 2019.

The textiles here have been organized by several broad categories, beginning with type, and then by area of origin, dating and style. First are ikats and prints from India: the ikats woven in silk as "double ikats" (see the next paragraph) and known as *patola,* and two prints that are cotton chintz. Though made in India, these textiles were all found in Sumatra, with the *patola* being highly-prized heirlooms used ceremonially, and the prints being used widely in trade across Indonesia from Sumatra to the Eastern Islands. The trade cloths offered new patterns (for example, the *tumpal* or repeating triangles at the ends) and designs (for example, the "tree of life") that influenced locally-produced cotton ikat and batik textiles. Both types of Indian textiles were treasured for centuries throughout Indonesia and represented the status and wealth of a village or family.

A Batak woman weaving an ikat, using a backstrap loom. Sumatra, 1930. Licensed from Bridgeman Images 2019 [original from National Geographic Image Collection/ Bridgeman Images].

Next are ikats and other woven textiles organized by origin, moving West to East, from Sumatra to Borneo, Sulawesi, Bali, and Timor. For a detailed description of the production of ikats and the other weavings here, see John Guy, *Woven Cargoes: Indian Textiles in the East* (1998). But generally, ikat involves resist dyeing, prior to weaving, of sections of bundled yarns in a predetermined (by memory or pattern grid) color scheme. For "single" ikats, the dyed weft threads are woven back and forth across and through the warp threads. Each color requires a separate dye bath; accordingly, the areas in the thread bundles *not* to be dyed a particular color are wrapped with an impermeable substance such as wax, mud, plain thread, or sometimes palm fiber, all to *resist* the particular dye in each bath. The bundle is then unwrapped, dried, rewrapped, and the process is repeated for the next color. Eventually, when the wefts are woven through the warp, very precise and beautiful patterns emerge. In a very few areas (Gujarat and Telengana in India, Bali in Indonesia and Okinawa in the Ryukyu Islands), this technique was used for *both* the warp and weft threads with incredibly intricate designs and precision. For all of these pieces, the material was handspun or commercial cotton, silk, or sometimes a mixture of the two.

Particularly in Borneo, the motifs are often abstract and symbolic, though crocodiles and serpents sometimes appear, as well as patterns borrowed from Indian *patola.* See Traude Gavin, *The Women's Warpath* (1996) at 79. In Sumba, river and sea animals and human figures often play a larger role, together with geometric figures borrowed from Indian motifs. See Marie Jeanne Adams, *Decorative Arts of Sumba* (1999) at 40. These cloths are woven on a back strap

loom (also known as back tension loom). On such a loom, the width (or weft) of each section cloth is limited to the horizontal reach of the weaver; accordingly, these cloths are often made in two identical (or as identical as hand weaving allows) long sections that are then sewn together along the warp length to produce the large resulting garments or decorative pieces.

Lastly are batiks, mostly from Java. The first three are the oldest batiks in our collection, each of which has been analyzed by radiocarbon dating and found to originate in the 17th and 18th centuries, respectively. These batiks are made on handspun cotton. We placed these "proto-batiks" first in this group because until the past 20 years or so, scholars assumed batiks had not survived the tropical climate, as well as damage from rodents and insects of equatorial Indonesia after the late 18th century. Since Dutch traders had greatly preferred Indian textiles to those of Indonesia prior to the failure of the Dutch East India Company (the "VOC") in 1799, and to the publication of *The History of Java* as described above, few examples were collected contemporaneously. Indeed, the famed Tropenmuseum in Amsterdam, containing around 3,000 batiks, has said the earliest piece in its collection was made around 1840. See van Hout (2001) at 16.

The late textile scholar and preeminent dealer Mary Hunt Kahlenberg knew the word "batik" appeared in Javanese sources in the early 17th century and actively sought to find examples that might have survived since then. In the 1990's she, and later others, found a few such batiks, dated some 150 years earlier than the examples in the Tropenmuseum. While 18th-century batiks have now also been documented, surviving pre-19th century examples remain relatively rare, and pre-18th century examples are very rare.

Indonesian women applying wax with a canting to batik between dyeings. Java, 1900-1915.
Licensed © BY-SA 3.0.

Indonesian woman applying wax with a canting to a batik. Java, 1920-1940. © BY-SA 3.0.

The process of making batiks, like that of ikats, involves resist dyeing but the figures are hand drawn (or in less fine pieces made after about 1840, imprinted with a *cap* or metal stamp) in wax, mixed with tree resins and gums, as well as animal fats, based on the experience and knowledge of each maker) on cotton fabric, and then the areas *not* to be dyed are coated with wax to *resist* the dye. The cloth is then dipped in dye of the desired color. After the piece has dried, the wax is scraped from or boiled off of the next area to be dyed and the areas already dyed are covered with wax. The wax removed after each dyeing is preserved and reused as long as possible. This process is repeated until all of the design has been colored, and may require one to two years to complete. For a more complete description of the batik process, see Elliott at 50.

The batiks here are from Sumatra and Java (the great mother-temple of batik artistry), ranging in age, after the proto-batiks described above, from the early 19th century to mid-20th century. They vary in style from the most traditional, including those distinctive in color and pattern from the *kratons* (palaces) of the sultans, Indian influences from chintz and other Indian imports, to Chinese-inspired depictions of animals, insects, plants and flowers, to French-inspired Art Nouveau mostly via Batik Belanda (batiks designed and made in the studios of Dutch and Eurasians, 1840-1940). The extraordinary detail and intricate patterns on many of these pieces, as contrasted with the proto-batiks, was made possible by the use of mill-made cotton from England first imported in significant quantities during Sir Stamford Raffles's time in Java. In 2009 UNESCO recognized the contribution of Indonesian batiks to world culture by officially inscribing them in the Representative List of the Intangible Cultural Heritage of Humanity.

In the following photos and descriptions, batiks that were sewn at each narrow end to be worn as sarongs have been left sewn; those unsewn have been left unsewn, and in many cases likely were never worn or washed by the owner. Styles, dates (some more precise than others), signatures or initials (where seen), and sizes are all noted on each descriptive page. For each piece, a photograph of the batik as a whole is accompanied, where warranted, by a detail of some particularly interesting section, which highlights the skill and imagination of the maker.

This collection of Indonesian textiles and some related Indian textiles that were popular and influential in Indonesian usage and design came together in a series of collecting periods spanning nearly forty years. When we were not looking at textiles, we were focused on Chinese and Japanese porcelain, pottery and sculpture. Whichever area we were studying and collecting, we bought primarily pieces we liked and wanted to live with, rather than systematically seeking to fill geographic, temporal or stylistic gaps. Eventually, because the pieces filled so much storage space in our home where relatively little could be displayed, we decided to start giving the textiles to the Asian Art Museum of San Francisco – Chung Moon Lee Center for Asian Art and Culture, where they can be safely stored, more thoroughly studied, conserved where needed, and displayed from time to time. Most of the pieces in this book now reside in that Museum. The Chinese and Japanese objects, which include some modern as well as ancient pieces, remain with us and may be the subject of a future volume.

Joan, Claire and Glenn Vinson

San Francisco, California
June 7, 2016; May 31, 2018

Map of Indonesia

1. SUMATRA
2. JAVA
3. BALI
4. LOMBOK
5. SUMBAWA
6. SUMBA
7. FLORES
8. SOLOR

9. ADONARA
10. LEMBATA
11. KEDANG
12. ALOR
13. SAVU
14. ROTI
15. WEST TIMOR
16. TIMOR-LESTE

17. TANIMBAR ISLANDS
18. WEST PAPUA
19. SERAM *(Maluku)*
20. HALMAHERA
21. SANGIHE
22. SULAWESI *(Celebes)*
23. SARAWAK, MALAYSIA
24. KALIMANTAN, INDONESIA

PHILIPPINES

PACIFIC
OCEAN

21

20

22

Maluku

19

18

11

9 12

7

17

8 10

16

6 13 14 15

lands

AUSTRALIA AUSTRALIA

Sumatra

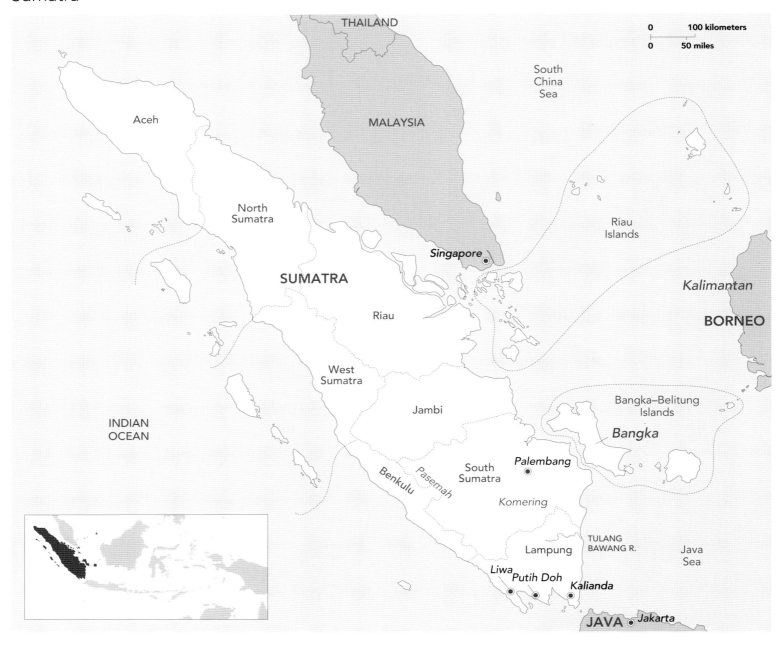

THAILAND

MALAYSIA

South
China
Sea

Aceh

North
Sumatra

Singapore

Riau
Islands

Kalimantan

SUMATRA

BORNEO

Riau

West
Sumatra

Jambi

INDIAN
OCEAN

Bangka–Belitung
Islands

Bangka

Benkulu

Pasemah

South
Sumatra

Palembang

Komering

Lampung

TULANG
BAWANG R.

Java
Sea

Liwa

Putih Doh

Kalianda

JAVA

Jakarta

Java

Borneo

Usage Notes

OBJECT INFORMATION

Information for each work is given in the following order:

1) Name (or use) of cloth in original language,
 followed in italics by name or use in English;

2) Geographic origin of maker, followed by location of use;

3) Material used in fabrication;

4) Techniques of fabrication;

5) Date of construction;

6) Measurements (length [warp] by width [weft],
 inches followed by metric;

7) Tubular shape where relevant.

LANGUAGE AND SPELLING

Many terms, technical and otherwise, are given in Bahasa Indonesia, the national language. Please consult the glossary for terms not explained in the text.

List of Textiles

INDIAN PATOLA AND PRINTS

IKATS, BROCADES, EMBROIDERY AND SONKETS

BATIKS (all Javanese except as noted)

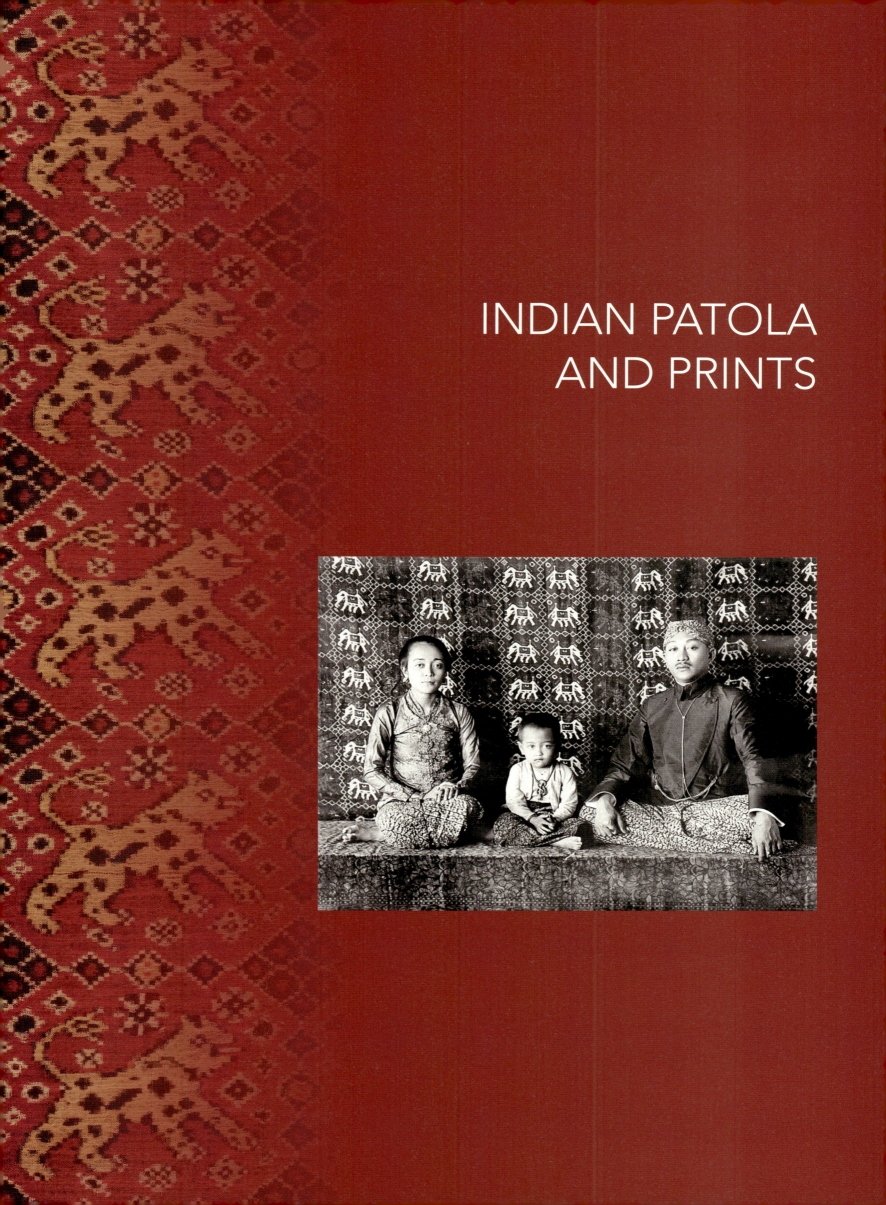

INDIAN PATOLA
AND PRINTS

Patolu –
Giant Elephants

Gujarat
India for the Indonesian Market

Silk
Double ikat
18th – early 19th century
155 x 38 in. (393.7 x 96.5 cm)

Rare ceremonial textile often given by the VOC to Indonesian nobles and village chiefs by whom they were held in great esteem. The flower and triangle *(tumpal)* motifs influenced textile design in much of Indonesia (though not Borneo). See Guy at 51.

ACQUISITION NUMBER 17877

25

Patolu – *100 Tigers*

Gujarat
India

For the Indonesian market (collected in Sumatra)
Silk
Double ikat
19th century
300 x 48 in. (762 x 121.9 cm)

This style of tiger is characteristic of Gujarat.

ACQUISITION NUMBER 1004

Kain Sembagi –
ceremonial cloth

Coromandel Coast, India for the Indonesian market
Collected in Lampung, Sumatra

Resist and mordant dyed handspun cotton
18th century
100 x 43 in. (254 x 109.2 cm)

This type of print was exported from India by the VOC in large quantities for trade in Indonesia.

ACQUISITION NUMBER 16054

Palampore –
*decorative hanging
with "tree of life" motif*

**Coromandel Coast
India for the Persian market; collected in Indonesia**

Cotton
Resist and mordant dyed
Late 19th century
82 x 47 in. (208.3 x 119.4 cm)

Although produced primarily for the Persian market, this
design was traded also in Indonesia. See Guy at 48-51.

ACQUISITION NUMBER 1006

IKATS, BROCADES, EMBROIDERY AND SONGKETS

Ragi Harangan –
shoulder cloth

Toba Batak people
North Sumatra
Indonesia

Cotton (handspun and commercial)
Supplementary weft and warp patterning with stipples
19th century
84 x 48 in. (213 x 122 cm)

Lake Toba, in central Sumatra, is the largest volcanic lake in the world. Toba Batak people live along the south coast of Lake Toba. *Ragi Harangan* means "bush of low trees; a small bush where the trees are not yet very old." See Niessen at 272.

ACQUISITION NUMBER 19819

Tengkuluak –
woman's headcloth, or Selendang – woman's shoulder cloth

Minangkabau people
Possibly Batusangkar village
West Sumatra

Silver and gold brocade on silk
19th century
94 ½ x 21 ½ in. (240 x 69.9 cm)

Minangkabau are a matrilineal society in West Sumatra.

ACQUISITION NUMBER 19821

Ceremonial Belt

Minangkabau people
West Sumatra
Indonesia

Cotton, silk, metallic wrapped threads
brocade
19th century
96 x 8 in. (243.8 x 20.3 cm)

39

Ija Sawak –
shoulder cloth or waist cloth

Aceh
North
Indonesia

silk and metal-wrapped threads
Songket supplementary weft
19th century
118 x 29 in. (299 x 73.7 cm)

See Maxwell (1990) at 331 plate 472 for a similar example.

ACQUISITION NUMBER 22969

Tampan Darat –
polychrome ritual cloth

Paminggir people
Lampung
Sumatra
Indonesia

Handspun cotton
Supplementary weft
First half 19th century
33 ½ x 27 ¾ in. (85.1 x 70.5 cm)

This motif is possibly a hornbill.

ACQUISITION NUMBER 1002

Tampan Darat –
ritual cloth

Paminggir people
Lampung
Sumatra
Indonesia

Handspun cotton
Supplementary weft
19th century
29 x 28 ¼ in. (74 x 72 cm)

ACQUISITION NUMBER 22979

Tampan Kalianda – *polychrome ritual cloth*

Kalianda people
Kalianda area
Lampung
Sumatra
Indonesia

Cotton
Supplementary weft
19th century or earlier
From the Samuel Josefowitz Collection
32 x 30 in. (81.3 x 76.2 cm)

ACQUISITION NUMBER 12210

44

Tampan Darat –
ritual cloth

Paminggir people
Lampung
Sumatra
Indonesia

Cotton and silk
Supplementary weft
Circa 1890
28 ½ x 24 ¼ in. (72.4 x 61.6 cm)

Palepai –
ceremonial textile

Paminggir people
Lampung
Sumatra
Indonesia

Double red-ship motif
Handspun cotton, supplementary weft
Late 18th – early 19th century
156 x 32 in. (396.2 x 81.3 cm)

47

Tapis Inuh – *with cumi-cumi (squid) motif*

Lampung
Sumatra
Indonesia

Handspun cotton, silk
Warp ikat and embroidery, mirror pieces or mica
19th century or earlier
From the Dr. Samuel Eilenberg Collection
49 x 32 in. (124.5 x 81.3 cm)

ACQUISITION NUMBER 5806

Ceremonial Cloth – *used for covering a sirih (betel nut) box*

Abung people, Kota Bumi District
Lampung
Sumatra
Indonesia

Silk floss embroidery on indigo dyed cotton ground
Embroidery
19th century
19 x 19 in. (48.3 x 48.3 cm)

See Maxwell 1990 at 202 for a similar example.

Tapis Tua –
woman's ceremonial skirt

Abung people
Lampung
Sumatra
Indonesia

Warp faced silk and cotton fabric with cotton weft brocaded
with silver and gold wrapped threads, hand-made sequins
Embroidery
Early 19th century
52 x 44 in. (132 x 105 cm)

ACQUISITION NUMBER 13148

Selendang –
woman's shoulder cloth

Komering people
Lampung
Sumatra
Indonesia

Silk, cotton, gold- and silver-wrapped threads
Supplementary weft
19th century or earlier
100 x 41 ¼ in. (254 x 105 cm)

ACQUISITION NUMBER 21439

Bidak Galah Napuh –
nobleman's wrap

Lampung
Sumatra
Indonesia

Silk, metallic threads
Weft and supplementary weft, metallic threads, two panels
sewn together
19th century
79 ½ x 41 in. (201 x 104 cm)

Bidak – *nobleman's wrap (partial)*

Pasemah
Southwest Sumatra
Indonesia

Handspun cotton
Red and blue stripes alternating with ikat stripes
19th century
58 x 20 ¼ in. (147.3 x 51.4 cm)

Tapis –
woman's wedding garment

Lampung
Sumatra
Indonesia

Handspun cotton
Gold embroidery on
silk and handspun cotton
1900-1920
51 ¼ x 41 ¾ in.
(131.4 x 106 cm)

ACQUISITION NUMBER 14010

Dringin –
ceremonial belt or sash

Palembang
Sumatra
Indonesia

Cotton, silk
Songket supplementary weft
Late 19th – early 20th century
204 x 3 in. (518.2 x 7.6 cm)

Kain Limar – *ceremonial cloth with serat nanas (pineapple fiber) used in place of gold thread*

Lampung
Sumatra
Indonesia

Silk and palm fiber
19th century
71 x 22 ½ in. (180.3 x 57.1 cm)

ACQUISITION NUMBER 13970

Selendang –
with metallic threads

Palembang
Sumatra
Indonesia

Silk, metal threads
Songket supplementary weft
1920
77 x 30 ½ in. (195.6 x 77.5 cm)

ACQUISITION NUMBER 1007

Lawon – *presentation cloth*

Palembang area
Sumatra
Indonesia

Silk
Tritik (sewn and dyed)
Late 19th – early 20th century
81 x 29 ½ in. (206 x 75 cm)

ACQUISITION NUMBER 16443

Pua Kumbu – *ceremonial cloth with white border*

Iban Dayak people
Sarawak (Borneo)
Malaysia

Handspun cotton
Warp ikat
19th century
91 x 49 ½ in. (231.1 x 122.5 cm)

Pua Sungkit –
buah naga or buah nebau (serpent-dragon motif) ritual cloth

Iban Dayak people
Kalimantan (Borneo)
Indonesia

Handspun cotton
Discontinuous supplementary weft
19th century
From the Sheldon Kent Collection, Chicago
82 x 39 in. (208.3 x 99.1 cm)

ACQUISITION NUMBER 12616

Pua Sungkit –
ceremonial cloth

Iban Dayak people
Sarawak (Borneo)
Malaysia

Handspun cotton
Discontinuous supplementary weft
Mid-19th century or earlier
88 x 21 ¼ in. (223.5 x 54 cm)

ACQUISITION NUMBER 1001

Pua Kumbu – *ceremonial cloth with Buah Penyandih Ngelai (stubby python)*

Iban Dayak people
Sarawak (Borneo)
Malaysia

Handspun Cotton
Warp Ikat
Late 19th – early 20th century
95 x 53 ½ in. (241.3 x 135.9 cm)

Published, Fischer at 77

ACQUISITION NUMBER 5710

Pua Kumbu –
ceremonial cloth

Iban Dayak people
Sarawak, Betong Division (Borneo)
Malaysia

Cotton (handspun and commercial)
Warp ikat
Early 20th century
84 x 32 in. (213.4 x 81.3 cm)

ACQUISITION NUMBER 22933

Pua Kumbu – *ceremonial cloth with tendril motif*

Iban Dayak people
Sarawak (Borneo)
Indonesia

Handspun cotton
Warp ikat
19th century
78 x 38 in. (198.1 x 96.5 cm)

ACQUISITION NUMBER 12598

Kamben Cepuk –
ceremonial textile

Bali
Indonesia

Handspun cotton
Weft ikat
19th century
89 x 23 in. (226 x 58.4 cm)

ACQUISITION NUMBER 22631

Kamben Cepuk –
ceremonial textile

Bali (Buleleng or Tabanan Agency)
Indonesia

Silk
Weft ikat
Mid-19th century
98 x 35 in. (248.9 x 88.9 cm)

A silk Kamben Cepuk is extremely rare; most are cotton.
For example see acquisition number 22631 on previous page.

ACQUISITION NUMBER 22629

Kamben – *hip cloth*

Batur
Bali
Indonesia

Cotton, gold wrapped threads
Songket supplementary weft *(endek)*
19th century
92 x 39 in. (233.7 x 99 cm)

Geringsing Wayang Kebo –
*sacred cloth with three-
figure shadow puppet motif*

Tenganan
Bali
Indonesia

Handspun cotton, knotted fringe on each end,
very saturated colors
Double ikat
20th century, collected by Mary Kahlenberg in Bali,
in the late 1970's
85 x 20 in. (215.9 x 50.9 cm)

Geringsing Wayang Kebo –
sacred cloth with two-figure shadow puppet motif

Tenganan
Bali
Indonesia

Handspun cotton
Double ikat
Late 19th – early 20th century
89 x 19 ½ in. (226 x 49.5 cm)

ACQUISITION NUMBER 1011

Hinggi – *man's hip or shoulder wrap with pohon andung (skull tree) motif*

Sumba people
East Sumba, possibly Kanatang District
Indonesia

Cotton
Warp ikat with woven decorative end bands (kabikil)
Late 19th or very early 20th century
108 x 44 in. (274 x 111.8 cm)

Hinggi – *man's wrap with lobster and "tree of life"*

Sumba people
East Sumba
Indonesia

Cotton
Warp ikat
1890-1920
From a private Dutch collection
109 x 52 in. (276.9 x 132.1 cm)

ACQUISITION NUMBER 12353

Hinggi – *man's hip or shoulder wrap*

Sumba people
East Sumba
Indonesia

Cotton
Warp ikat
Late 19th or early 20th century
105 x 46 in. (266.7 x 116.8 cm)

ACQUISITION NUMBER 2007

89

Hinggi – *man's wrap with patola geometric center and facing animals*

Sumba people
East Sumba
Indonesia

Cotton
Warp ikat
Early 20th century
From the Emil Delbon Collection, Antwerp, Belgium
108 x 66 in. (274.3 x 167.6 cm)

ACQUISITION NUMBER 12629

Hinggi – *man's wrap with shrimp motif viewed in profile*

Sumba people
East Sumba
Indonesia

Cotton
Warp ikat and twining
Circa 1930's
114 x 54 in. (289.6 x 137.2 cm)

ACQUISITION NUMBER 12594

Lau Pahikung Hiamba – *noblewoman's wrap*

Sumba people
Possibly Rindi Province
East Sumba
Indonesia

Cotton, two-ply
Warp ikat
Early 20th century
106 x 55 in. (269.2 x 139.7 cm)

ACQUISITION NUMBER 22983

Lau Pahudu –
queen's ritual sarong

Sumba people
East Sumba
Indonesia

Cotton
Supplementary warp ikat, gold staining
Early 20th century
From the van Lier collection, Netherlands
63 x 29 in. (160 x 73.7 cm) sewn dimensions as a sarong

ACQUISITION NUMBER 11288

Lau Pahudu – *lower half of queen's ritual sarong*

Sumba people
East Sumba
Indonesia

Cotton
Supplementary warp ikat, gold staining
Early 20th century
From an old Dutch collection
27 x 26 in. (68.6 x 66 cm) sewn dimensions as a sarong

ACQUISITION NUMBER 12603

Hinggi –
indigo man's wrap

Sumba people
East Sumba
Indonesia

Cotton
Warp ikat
1980
96 x 41 ¼ in. (241.8 x 104.5 cm)

ACQUISITION NUMBER 1010

Lau Pahudu –
queen's ritual sarong

Sumba people
East Sumba
Indonesia

Cotton
Supplementary warp ikat, gold staining
Early 20th century
From the collection of Baron Freddy Rolin, Belgium.
117 x 33 in. (297.2 x 83.8 cm) sewn dimensions as a sarong

When collected, this piece was used as a valence to set
off a sacred space in a room; this piece could also be half
of an unfinished lau.

ACQUISITION NUMBER 15572

Pahudu – *decorative panel with dragons and "tree of life"*

Sumba people
East Sumba
Indonesia

Cotton
Supplementary warp
Mid-20th century
51 x 30 ½ in. (129.5 x 77.5 cm)

ACQUISITION NUMBER 1008

Sekomandi – *funerary cloth with sekong (interlocking ancestors) motif or ceremonial hanging*

Toraja people
Sulawesi (Kalumpang region)
Indonesia

Cotton
Warp ikat
19th century
From the Emile Deletaille collection, Brussels
58 x 49 in. (147.3 x 124.5 cm)

Pewo, Mbesa Tali to Batu – *"Headcloth of the Stoneman"*

Toraja people
Rongkong or Palu area
Central Sulawesi
Indonesia

Cotton
Slit tapestry or discontinuous wefts in cotton, woven in openwork designs that are then tie-dyed
19th century or earlier
114 x 10 ½ in. (290 x 27 cm)

While this type of cloth is generally thought to have been wrapped around the head of the deceased prior to interment, the name given to this specific type may refer to it being wrapped around the heads of megalithic stone figures. See Solyom, figure 59; Kahlenberg (2010) at 262.

ACQUISITION NUMBER 22988

Maa' – ceremonial sacred cloth

Toraja people
Sulawesi
Indonesia

Homespun cotton
Hand-painted and stamped
Late 19th – 20th century
80 x 26 in. (203 x 66 cm)

ACQUISITION NUMBER 12163

Abaca fiber – *decorative cloth*

Sangihe Island
Sangihe and Talaud Islands (Indonesia)

Abaca fiber cloth, supplementary weft
Late 19th – early 20th century
37 ⅛ x 16 ½ in. (94 x 42 cm)

The Sangihe and Talaud Islands stretch between northeast Sulawesi and the Philippines. These cloths were used for clothing or sewn together to make room dividers, curtains, other furnishings and sometimes sarongs. See Gittinger (1979) at 211, Majlis at 423.

ACQUISITION NUMBER 23232

Lawo – *woman's ritual sarong*

Ili Api or Kalikur; Lamaholot People
Lembata Island
Indonesia

Cotton and silk
Ikat
Circa 1850
68 x 25 in. (172.7 x 63.5 cm)

Lawo – *woman's ritual sarong*

Ile Api District
Lembata
Indonesia

Cotton
Ikat
19th century
58 x 28 in. (147.3 x 71.1 cm)

ACQUISITION NUMBER 12601

Lawo Butu –
woman's ritual sarong

Ngadha people
Central Flores
Indonesia

Cotton
Ikat
19th century
66 x 32 in. (167.6 x 81.3 cm)

Exhibited, *Threads of Tradition, Textiles of Indonesia and Sarawak* (Lowie Museum of Anthropology, U. C. Berkeley, 1979).

ACQUISITION NUMBER 12600

Adat Sarong – *ceremonial*

Savu
Hubi Ae (Greater Blossom) moiety
Indonesia

Cotton
Warp ikat
First half 20th century
61 x 21 in. (154.9 x 53.3 cm)

For similar examples, see Maxwell at 358.

ACQUISITION NUMBER 15540

Adat Sarong –
ceremonial

Savu
Hubi Iki (Lesser Blossom) moiety
Indonesia

Cotton
Warp ikat
First half 20th century
64 x 23 in. (162.6 x 58.4 cm)

For similar examples, see Maxwell at 358. Although an *adat* textile, this example shows European influence in its design.

ACQUISITION NUMBER 15526

Hi'i Wo Hepi Selendang – man's shoulder cloth

Savu
Hubi Ae (Greater Blossom) moiety
Indonesia

Cotton
Warp ikat
First half 20th century
86 x 35 in. (218.4 x 88.9 cm)

See McIntosh at 286.

Lawar or Homnon – sarong

Luang Island or Kisar Island
West Moluku
Indonesia

Handspun cotton
Warp ikat
Mid-20th century or earlier
57 ¼ x 24 ½ in. (145.4 x 62.2 cm)

ACQUISITION NUMBER 23201

BATIKS

Proto-Batik Prada – *hanging*

Possibly Northeast Java
Indonesia

Handspun cotton
Batik, gold overlay
17th – 18th century, C14 tested 1675-1755
107 x 66 ½ in. (271.8 x 168.9 cm)

This design is known as a *kotak seribu* (thousand compartments). The large size suggests its use as a hanging, in which case the wear indicates it was hung vertically.

ACQUISITION NUMBER 21716

Proto-Batik Kemben – *woman's torso wrapper*

Gresik or Cirebon
Java
Indonesia

Handspun cotton and woven cotton
Batik
17th century (C14 tested)
120 x 28 in. (304.8 x 71.1 cm)

ACQUISITION NUMBER 18232

Proto-Batik Dodot –
ceremonial skirt cloth

Solo or North East Coast
Java
Indonesia

Handspun cotton
Batik
Circa 1800 (C14 tested)
From the collection of the Dutch Missionary Society
102 x 53 in. (259.1 x 134.6 cm)

129

Kain Simbut –
ceremonial cloth

Rangkasbitung
West Java
Indonesia

Rice paste resist on palm fiber
Batik
Early 20th century
52 x 30 ½ in. (142 x 72 cm)

Kain Simbut were used to repel evil influences during life crises ceremonies such as birth, circumcision and tooth filing.

ACQUISITION NUMBER 16052

Islamic Calligraphic
ritual or ceremonial textile

Cirebon (Java) or Jambi (Sumatra)
Indonesia

Cotton
Batik
Late 19th – early 20th century
82 x 35 in. (208.3 x 88.9 cm)

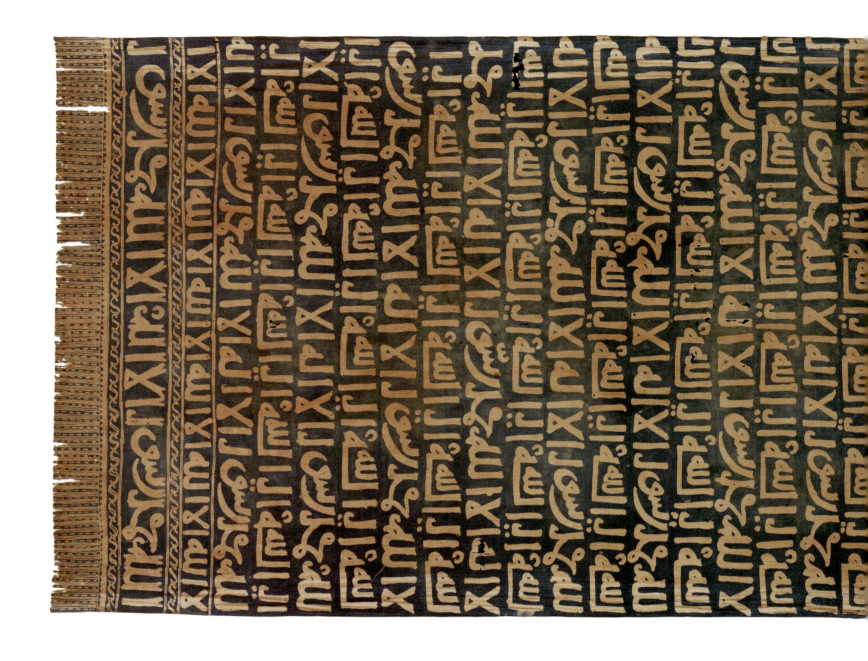

Islamic Calligraphic Batik – blue with white writing

Cirebon
Java
Indonesia

Cotton
Batik
Early 20th century
118 x 42 in. (300 x 107 cm)

Acquisition number 11771

Selendang –
with geometric pattern

Jambi (Sumatra) or
Cirebon (Java) for the South Sumatra market
Indonesia

Cotton
Batik
19th century
81 x 35 in. (205.7 x 88.9 cm)

ACQUISITION NUMBER 12433

Sarong – *ceremonial garment with mountains, Garuda wings and birds*

Cirebon
Java
Indonesia

Cotton
Batik
Late 19th century
Collected by Mary Kahlenberg in 1993
75 x 41 in. (190.5 x104 cm)

ACQUISITION NUMBER 15010

Saput – hanging to
Ceremonial Textile

Cirebon or Indramayu
Java
Indonesia

Cotton
Kain batik prada – *batik cloth with gold*
19th century
From the Harry Packard Collection
77 x 24 ¾ in. (195 x 62.9 cm)

Sarong – *with red turtles and deer*

Cirebon
Java
Indonesia

Cotton
Batik
1890-1915
74 x 42 in. (188 x 105 cm)

Sarong Kelengan –
in Chinese Art Nouveau style perhaps influenced by Chinese ceramics

Cirebon
Java
Indonesia

Cotton
Batik
1905
79 x 42 in. (200.7 x 106.7 cm)

ACQUISITION NUMBER 15055

Kain Panjang – *with garis miring (diagonal stripes) design worn as a sarong*

Cirebon
Java
Indonesia

Cotton
Batik
Early 20th century
47 x 40 in. (119.4 x 101.6 cm)

Possibly from a member of the Cirebon court.

145

Kain Panjang –
hip wrapping/skirt cloth,
Labang aneka filosfi
Kehidepan *motif*

Kraton Kanoman
Cirebon
Java
Indonesia

Cotton
Batik
Circa 1910
102 x 42 in. (259 x 107 cm)

Lambang aneka filosofi kehidupan (symbols of the various philosophies of life)

ACQUISITION NUMBER 22627

147

Kain Panjang –
hip wrapping with flowers and birds

Tegal
Java
Indonesia

Cotton
Batik
1910-1930
Acquired by Mary Kahlenberg in 1980.
105 x 41 in. (269 x 104.1 cm)

The clean white background is relatively uncommon because of the difficulty of protecting the background from cracks in the wax during successive dyeing for each of the other colors.

149

Sarong –
French Baroque style

Pekalongan
Java
Indonesia

Cotton
Batik
1900
Signed "E. van Zuylen"
41 x 40 in. (104.1 x 101.6 cm), tubular (sewn)

ACQUISITION NUMBER 19734

151

Sarong with Ganggeng (floating seaweed) motif – *with animals*

Pekalongan
Java
Indonesia

Cotton
Batik
1910
78 x 41 in. (198.1 x 104.1 cm)

ACQUISITION NUMBER 15084

153

Sarong – *wisteria and peacock design*

Pekalongan
Java
Indonesia

Cotton
Batik
1900-1920
Signed "Ny Oey Kok Seng" (an artist in the van Zuylen workshop)
(stamp circa 1930).
80 x 44 in. (203.2 x 111.8 cm)

Illustrated in van Hout at 32; related piece on cover of Veldhuisen.

ACQUISITION NUMBER 15063

Sarong

Pekalongan
Java
Indonesia

Cotton
Batik
Pre-1920
Signed by Liem Soen Lian
41 x 35 in. (104.1 x 99.1 cm) tubular (sewn)

ACQUISITION NUMBER 20523

Kain Panjang –
hip wrapping/skirt

Kedungwuni
Java
Indonesia

Cotton
Batik
1930-1950
Signed "Oey Soe Tjoen"
103 x 43 in. (261.6 x 100.2 cm)

Oey Soe Tjoen was a male designer and craftsman of the finest quality batik. For more details on specific batik designers, see generally Heringa and Veldhuisen 1996.

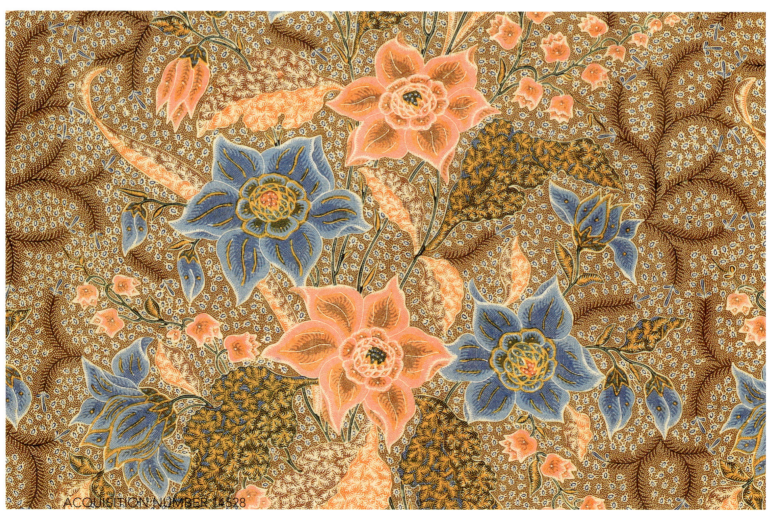

Sarong

Pekalongan
Java
Indonesia

Cotton
Batik
1930's
Signed "The Tie Sied"
85 x 42 in. (215.9 x 106.7 cm) tubular (sewn)

The Tie Sied was an important male batik designer.
For biographical information and similar designs, see
Heringa and Veldhuisen at 80, 165 and 181.

ACQUISITION NUMBER 13287

Sarong – *with flowers, birds and insects*

Pekalongan
Java
Indonesia

Cotton
Batik
1920-1930
Signed by Oey Jian
41 x 39 ¾ in. (104.1 x 95.9 cm) tubular (sewn)

ACQUISITION NUMBER 17460

Sarong – *with pineapples and flowers*

Kudus
Java
Indonesia

Cotton
Batik
1900-1930
95 x 41 ¼ in. (241.3 x 104.8 cm)

ACQUISITION NUMBER 2004

Sarong Peranakan

Kudus
Java
Indonesia

Commercial Cotton
Batik
1920-1930
Signed "Nie Boen In"
78 x 41 in. (198.1 x 104.1 cm)

For biographical information see Elliott at 144 entry on Nie (Lie)
Boen In.

ACQUISITION NUMBER 15072

Kain Panjang –
hip wrapping/skirt

Lasem
Java
Indonesia

Cotton
Batik
Late 19th – 20th century
115 x 41 in. (292.1 x 104.1 cm)

ACQUISITION NUMBER 16560

Sarong – *with birds and "tree of life"*

Lasem
Java
Indonesia

Cotton
Batik
1890-1910
86 x 42 in. (218.4 x 106.7 cm) tubular (sewn)

For similar examples, see Heringa and Veldhuisen at 30, 92.

Kudung
(woman's head cloth)

Lasem
Java
Indonesia

Cotton
Batik
1910-1930
84.7 x 35 in. (215.3 x 88.9 cm)

Acquisition number 2006

175

Sarong – *with garis miring (diagonal lines)*

Lasem
Java
Indonesia

Cotton
Batik
1890-1915
81 x 41 in. (205.7 x 104.1 cm)

ACQUISITION NUMBER 2001

Sarong – *with big fish*

Lasem
Java
Indonesia

Cotton
Batik
1890-1915
41 x 81 in. (105.4 x 205.7 cm)

Kain Panjang – *with garis miring (diagonal lines) and Peranakan floral design*

Tiga Negeri (Lasem, Kudus, Solo)
Java
Indonesia

Cotton
Batik
Early 20th century
84 x 41 in. (213.4 x 104.1 cm)

ACQUISITION NUMBER 15078

Sarong –
for Solo Court

Tiga Negeri (Kudus, Lasem, Solo)
Java
Indonesia

Cotton
Batik
Early 20th century
Signed by Ibu Oey Netti
42 x 42 in. (106.7 x 106.7 cm) tubular (sewn)

Owned (but apparently never washed) by Gusti Raden Ayu Siti Nurul Kamaril Ngasarati Kusumawardhani. For a similar example, see Achjadi 1999 at 92.

ACQUISITION NUMBER 20395

180

Sarong – *with animals, insects and flowers*

Tiga Negeri (Kudus, Lasem, Solo)
Java
Indonesia

Cotton
Batik
1915-1930
41 x 38 in. (104.1 x 97.8 cm)

ACQUISITION NUMBER 18062

183

Sarong – *with tambal (patchwork) design*

North Coast Java
Indonesia

Cotton
Batik
1890-1915
48 ¾ x 40 ¾ in. (123.8 x 103.5 cm) tubular (sewn)

185

Tok Wie –
Chinese altar cloth

North Coast Java
Indonesia

Cotton
Batik
1900-1920
41 x 39 in. (104.1 x 99.1 cm)

The characters read: "fu lu shou chuan" (spread prosperity, status, longevity).

ACQUISITION NUMBER 13253

Sarong – *with garis miring (slanted lines), flowers and birds*

North Coast Java
Indonesia

Cotton
Batik
1920
96 ½ x 41 ½ in. (245.1 x 105.4 cm)

ACQUISITION NUMBER 2003

Sarong –
with auspicious animals

North Coast
Java
Indonesia

Cotton
Batik
Early 20th century
Signed "Thewienie"
84 x 41 in. (213.4 x 104.1 cm)

ACQUISITION NUMBER 17473

Selendang

Northeast Coast Java for the Bali market
Indonesia

Silk
Batik
Circa 1900
103 x 20 ½ in. (261.6 x 52.1 cm)

Kain Jarit – *with* semen *(leaf tendrils) pattern*

Northeast Coast
Java
Indonesia

Cotton
Batik
Early 20th century
114 x 42 in. (289.6 x 108 cm)

ACQUISITION NUMBER 22980

193

Selendang – shoulder cloth

Northeast Coast or Solo
Java
Indonesia

Handspun cotton
Batik
19th century
124 x 20 in. (315 x 50.8 cm)

Kain Kepala – *royal batik*

Kraton Solo
Java
Indonesia

Cotton
Batik
Early 20th century
From the Court of Sultan Pakubuwono X
42 ½ x 41 ¾ in. (108 x 106 cm)

At one end of the length are two letters that may be "Na."

Kain Panjang – *royal batik with* semen *(leaf tendrils) and* champaca *flower design*

Kraton Solo
Java
Indonesia

Cotton
Batik
Early 20th century
40 x 96 in. (101.6 x 243.8 cm)

Kain Panjang – *royal batik*

Kraton Yogyakarta
Java
Indonesia

Cotton
Batik
Late 19th – mid-20th century
From the collection of Princess B. R. A. Satoei Yamin
96 x 40 in. (243.8 x 101.6 cm)

The *soga* brown is characteristic of Central Java. The
patterns were prescribed since the 18th century for proper
court use. For similar examples, see Elliot at 64, 68.

ACQUISITION NUMBER 20112

Kain Panjang – *royal batik*

Kraton Solo
Java
Indonesia

Cotton
Batik
Early 20th century
From the Court of Sultan Pakubuwono X
42 ½ x 41 ¾ in. (108 x 106 cm)

ACQUISITION NUMBER 19789

Kemben – *torso wrapper*

Yogyakarta
Java
Indonesia

Cotton
Batik
Early 20th century
102 x 32 in. (259 x 81.3 cm)

ACQUISITION NUMBER 13193

Jarit –
woman's shoulder cloth

Gedong central hamlets
Kerek area
East Java
Indonesia

Handspun and woven cotton
Batik
Mid-20th century
102 x 42 in. (259 x 107 cm)

The motif on this batik is the *kenanga ginubah* (blossom of the kenanga tree, also known as *Ylang-Ylang*).

Glossary

For more extensive glossaries of batik, ikat and patola designs and usage, see any of the books listed under Some Useful References in the subsequent section. Most have a glossary covering their areas and subjects. The words describing Indonesian textiles originate from the Bahasa Indonesia (and variants in Bahasa Malaysia, Tagalog and local dialects), Chinese, Dutch and English languages.

Adat: customary law of the indigenous people of Malaysia and Indonesia; for textiles (*kain adat),* suitable for ceremonial occasions.

Alas-alasan: resembling a forest with wild creatures of the sky, mountain and forest. Symbolizes the cosmos and fertility.

Badan: The body or main field of a batik.

Backstrap, back tension or body loom: a simple loom that uses a strap around the back of the weaver to hold the lengthwise threads (the warp) under tension while the weaver passes the crosswise threads (the weft) through the warp.

Batik: a wax-resist technique of dying.

Batik Belanda: Batik designed by Indo-Europeans in Pekalongan, Central Java, often signed or stamped by the designer.

Batik *Tulis:* Batik hand-waxed with a *canting* (q.v.).

Brocade: a supplementary weft technique produced by adding a non-structural, ornamental weft in addition to the standard weft that holds the warp threads.

Canting (pronounced "chanting"): a small tool used to apply melted wax designs (the reserve or the area not to be dyed) to the cloth.

Cap (pronounced "chop"): a stamp, resembling a flat iron, usually made from copper strips welded or soldered together to form the outline of the desired pattern, dipped in wax and used to impress the wax onto the cloth.

Carbon-14 dating: a method of estimating, through laboratory measurement, when organic material (such as cotton, silk or wood) was living, based on the natural decay or disintegration of the Carbon 14 isotope ingested by breathing, eating or photosynthesising carbon dioxide from the atmosphere; also known as C-14 dating.

Champaca: the sweet-scented "provincial" flower of Central Java, also endemic in Bali.

Dringin: ceremonial belt.

Endek: Balinese version of weft ikat.

Ganggeng: floating seaweed.

Garis miring: design of diagonal lines or stripes.

Garuda: a bird or bird-like creature, often a symbol of royalty, in Hindu, Buddhist and Jain mythology, commonly represented in batik imagery by one or two wings.

Geringsing wayang kebo: a double ikat textile with shadow puppet design made in Bali.

Hinggi: man's wrapper used as a mantle and/or a hip cloth.

Ikat: literally to tie or bind; a method of resist dying and weaving using palm leaf, threads, or plastic strips to prevent penetration of the dye from the warp or weft threads. For double *ikat* (known only in India, Bali and Japan), both warp and weft threads are tied and dyed prior to weaving. The Iban people in Borneo also use the term *kebat* for *ikat.*

Ikat (or *iket*) *kepala:* man's batik head wrapper, not to be confused with the textile weaving technique, *ikat.* However, *ikat kepala* (using the ikat weaving technique) also are made, particularly in Sumatra.

Kain: length of cloth, used in combination with descriptive terms, e.g. *kain kebat.*

Kain kebat: *ikat* skirt (Iban people, Borneo).

Kain panjang: long batik cloth wrapped around the hips; worn more formally than a sarong.

Kain songket: silk cloth decorated with gold or silver thread.

Kain tiga negeri: a batik cloth dyed in three production centers on the North Coast and in Central Java, usually Cirebon or Pekalongon (blue), Lasem (red), Kudus or Solo (soga or brown).

Kamben: Balinese sarong worn by women or men, sometimes worn around the upper body of women.

Kebaya: woman's loose blouse.

Kemben: Javanese cloth worn around the upper body of women.

Kepala: literally, head. Section at one or both ends or the middle of a *kain panjang* or *sarong*, decorated with a motif that differs in color or pattern from that of the *badan*. Also, a headdress.

Kepala tumpal: end panel design of a sarong or *kain panjang*, derived from Indian precedents comprised of rows of isosceles triangular motifs (*tumpal*).

Kraton: royal court.

Kumbu: patterened *ikat*, e.g. *pua kumbu* (ceremonial cloth).

Lau: women's tubular skirt in Sumba.

Maa', Ma'a, Mawa': a general term for a class of textiles held sacred by the Toraja, Sulewesi, including certain batiks, Indian prints and double ikats.

Moiety: each of two parts into which a thing is or can be divided; for Savu people, lines of descent are both patrilineal and matrilineal; the matrilineal lines are identified as Greater Blossom moiety or Lessor Blossom moiety.

Pahudu: a type of memory device used in East Sumba for maintaining the knowledge of patterns.

Patola (plural) or *patolu* (singular) : silk cloth from Gujurat using the double *ikat* technique.

Pesisir: coastal.

Prada: gold leaf or gold dust applied to batik.

Saput: decorative or ceremonial hanging cloth.

Sarong or *sarung*: cloth sewn to form a tubular skirt. Always includes a *kepala* section.

Sekong: an interlocking design which may symbolize ancestors (e.g., from Toraja, Sulawesi).

Selendang: breast, shawl or shoulder cloth for women.

Semen: profusion of sprouts, associated with fertility; leaf tendrils.

Serat nanas: pineapple fiber.

Seret: selvage borders on Javanese batik.

Sirih: betel nut.

Songket: type of brocade or supplementary weft often with metallic threads.

Sungkit: a patterning technique where warp threads are wrapped with colored threads at each insertion of the weft on a plain weave.

Tambal: patchwork.

Tampan darat: small square ritual cloth from the interior of Sumatra with supplementary weft technique.

Tapis: traditional woman's ceremonial skirt from Lampung.

Tok Wi: the Hokkien term for altar front or valance.

Tumpal: row of repeating triangles.

Wayang: literally "puppet" but more generally traditional theater, often of epic tales such as the Ramayana, often performed using shadow puppets (wayang kulit) or carved puppets (wayang golek).

Some Useful References

Barnes, Ruth, et al. *Trade, Temple & Court: Indian Textiles from the Tapi Collection*. Mumbai: India Book House Pvt. Ltd., 2002.

Cashman, Katrina, ed. *Encounters with Bali: A Collector's Journey: Indonesian Textiles from the Collection of Dr. John Yu AC & Dr. George Soutter AM*. Mosman: Mosman Art Gallery, 2014.

de Jonge, Nico and Toos van Dijk. *Forgotten Islands of Indonesia: The Art and Culture of the Southeast Moluccas*. Singapore: Periplus Editions, 1995.

Fischer, Joseph. *Threads of Tradition: Textiles of Indonesia and Sarawak*. Berkeley: UC University Art Museum, 1979.

Gittinger, Mattiebelle. *Splendid Symbols: Textiles and Tradition in Indonesia*. New Haven: Eastern Press, 1979.

Gittinger, Mattiebelle, ed. *To Speak with Cloth: Studies in Indonesian Textiles*. Los Angeles: University of California Museum of Cultural History, 1989.

Gittinger, Mattiebelle. *Master Dyers to the World: Technique and Trade in Early Indian Dyed Cotton Textiles*. Washington, D.C.: The Textile Museum, 1982.

Guy, John. *Woven Cargoes: Indian Textiles in the East*. New York: Thames & Hudson, 1998.

Hitchcock, Michael. *Indonesian Textiles*. Berkeley: Periplus Editions, 1991.

Kahlenberg, Mary Hunt, et al. *Asian Costumes and Textiles from the Bosphorus to Fujiyama: the Zaira and Marcel Mis Collecion*. Milan: Skira Editore, S.p.A., 2001.

Kahlenberg, Mary Hunt, ed. *The Extraordinary in the Ordinary: Textiles and Objects from the Collections of Lloyd Cotsen and the Neutrogena Corporation*. New York: Henry N. Abrams, Inc., 1998.

Kahlenberg, Mary Hunt and Ruth Barnes, ed. *Five Centuries of Indonesian Textiles*. London: Delmonico Books, 2010.

Kahlenberg, Mary Hunt. *Rites of Passage: Textiles of the Indonesian Archipelago from the Collection of Mary Hunt Kahlenberg*. San Diego: Mingei International Museum of World Folk Art, 1979.

Kahlenberg, Mary Hunt. *Textile Traditions of Indonesia*. Los Angeles: Los Angeles County Museum of Art, 1977.

Langewis, Lauren and Frits A. Wagner. *Decorative Art in Indonesian Textiles*. Amsterdam: C.P.J. van der Peet, 1964.

Majlis, Brigitte Khan. *The Art of Indonesian Textiles: The E. M. Bakwin Collection at the Art Institute of Chicago*. New Haven: Yale University Press, 2007.

Majlis, Brigitte Khan. *Woven Messages – Indonesian Textile Tradition in Course of Time*. Roemer Museum, Hildesheim, 1991.

Maxwell, John R. and Robyn J. Maxwell. *Textiles of Indonesia: An Introductory Handbook*. Indonesian Arts Society, 1976.

Maxwell, Robyn. *Sari to Sarong: Five Hundred Years of Indian and Indonesian Textile Exchange*. Canberra: National Gallery of Australia, 2003.

Maxwell, Robyn. *Textiles of Southeast Asia: Tradition, Trade and Transformation*. Melbourne: Oxford University Press Australia, 1990.

McIntosh, Linda S. *Thread and Fire, Textiles and Jewelry from the Isles of Indonesia and Timor.* Thailand: River Books, Co. Ltd., 2019.

Murray, Thomas. *C-14 Dating of Dayak Art.* Hong Kong: CA Design, 2015.

Puranananda, Jane, ed. *The Secrets of Southeast Asian Textiles: Myth, Status, and the Supernatural.* Bangkok: The James H. W. Thompson Foundation, 2007.

Sacred Threads: Ceremonial Textiles of Southeast Asia. Singapore: Textile Friends of Singapore, 2001.

Schefeld, Reimar and Steven G. Alpert, ed. *Eyes of the Ancestors: The Arts of Island Southeast Asia.* New Haven: Yale University Press, 2013.

Selections from the Steven G. Alpert Collection of Indonesian Textiles. Dallas: Dallas Museum of Art, 1984.

Solyom, Bronwen and Garrett. *Fabric Traditions of Indonesia.* Pullman: Washington State University Press, 1984.

Sibeth, Archin. *The Batak: Peoples of the Island of Sumatra.* New York: Thames and Hudson, Inc., 1991.

van Hout, Itie. *Indonesian Textiles at the Tropenmuseum.* Volendam: LM Publishers, 2017.

Wronska-Friend, Maria. *Balinese Textiles for Gods and People.* Leidzi, Poland: Central Museum of Textiles, 2015.

Ikat

Adams, Marie Jeanne. *Decorative Arts of Sumba.* Amsterdam: The Pepin Press, 1999.

Amann, Heribert. *Textiles from Borneo: Iban Kantu Ketungau and Mualang Peoples - Collected by Heribert Amann.* Milan: 5 Continents Editions, 2013.

Barnes, Ruth. *The Ikat Textiles of Lamalera: A Study of an Eastern Indonesian Weaving Tradition.* Leiden: E.J. Brill, 1989.

Desai, Chelna. *Ikat Textiles of India.* London, Thames and Hudson, 1989.

Djambatan, Penerbit. *Indonesian Ikats.* Jakarta: Djambatan, 1987.

Gavin, Traude. *The Women's Warpath: Iban Ritual Fabrics from Borneo.* UCLA Fowler Museum of Cultural History, 1996.

Hadden Alfred C. and Laura E. Start. *Iban or Sea Dayak Fabrics and their Patterns: a Descriptive Catalogue of the Iban Fabrics in the Museum of Archaeology and Ethnology Cambridge.* Bedford: Ruth Bean Publishers, 1982.

Hauser-Schäublin, Brigitta, et al. *Textiles in Bali.* Singapore: Periplus Editions, 1991.

Holmgren, Robert J. and Anita E. Spertus. *Early Indonesian Textiles from Three Island Cultures: Sumba, Toraja, Lampung.* New York: The Metropolitan Museum of Art, 1989.

Iwanaga, Etsuko, ed. *The Islands of Cotton Textiles in Indonesia: The Eiko Kusuma Collection.* Fukuoka: Fukuoka Art Museum, 2003.

Kartiwa, Dra. Suwati, M.Sc. *Indonesian Ikats.* Jakarta: Djambatan, 1987.

Kartiwa, Dra. Suwati, M.Sc. *Kain Songket Indonesia.* Jakarta: Djambatan, 1986.

Kreifeldt, John G., et al. *Woven Power: Ritual Textiles of Sarawak and Kalimantan,* Cantor Art Gallery, College of the Holy Cross, 2016.

Lee, Chor Lin. *Sacred Threads: Ceremonial Textiles of Southeast Asia.* Singapore: Asian Civilisations Museum, 2001.

Niessen, Sandra. *Legacy in Cloth: Batak Textiles in Indonesia*. KITLV Press: Leiden, 2009.

Taylor, Paul Michael and Lorraine V. Aragon. *Beyond the Java Sea: Art of Indonesia's Outer Islands*. Washington, D.C.: National Museum of Natural History, 1991.

Ten Hoopen, Peter. *Ikat Textiles of the Indonesian Archepelago.* Hong Kong: UMAG (University of Hong Kong), 2018.

Ten Hoopen, Peter. *Woven Languages: Indonesian Ikat Textiles from the Peter ten Hoopen Collection.* Lisbon: Museo do Oriente, 2015.

The Islands of Cotton: Textiles in Indonesia: The Eiko Kusuma Collection. Fukuoka: Fukuoka Art Museum, 2003.

van Dijk, Toos and Nico de Jonge. *Ship Cloths of the Lampung South Sumatera: A Research of their Design, Meaning and Use in their Cultural Context*. Amsterdam: Galerie Mabuhay, 1980.

Batik

Achjadi, Judi, ed. *Batik: Spirit of Indonesia.* Jakarta: Yayasan Batik Indonesia, 1999.

Achjadi, Judi. *The Glory of Batik: The Danar Hadi Collection*. Jakarta: P. T. Buku Antar Bangsa, 2010.

Batik: Traditional Textiles of Indonesia from the Rudolf Smend & Donald Harper Collections. Rutland: Tuttle Publishing, 2015.

de Marval, Gasper. *Sekar Jagad "Fleurs de L'Univers" Le Batik Javanais.* Saint-Quentin: Galerie Saint-Jacques, 2015.

Doellah, Santosa H. *Batik: The Impact of Time and Environment*. Jakarta: Danar Hadi, 2002.

Elliott, Inger McCabe. *Batik: Fabled Cloth of Java*. New York: Crown Publishers, 1984.

Fleischmann-Heck, Isa, et al. *Batik: 75 Selected Masterpieces: The Rudolf G. Smend Collection*. North Clarendon: Tuttle Publishing, 2006.

Heringa, Rens and Harmen C. Veldhuisen. *Fabric of Enchantment: Batik from the North Coast of Java*. Los Angeles: Los Angeles County Museum of Art and Weatherhill Inc., 1996.

Gluckman, Dale Carolyn and Sattarat Muddin, *A Royal Treasure, the Javanese Batik Collection of King Chulalongkorn of Siam.* Queen Sirikit Museum of Textiles, Bangkok, 2018.

Ishwara, Helen, et al. *Batik Pesisir: An Indonesian Heritage: Collection of Hartono Sumarsono*. Jakarta: KPG, 2012.

Kerlogue, Fiona. *Batik: Design, Style and History*. London: Thames & Hudson, 2004.

Lee, Peter, et al. *Auspicious Designs: Batik for Peranakan Altars*. Singapore: Asian Civilisations Museum, 2015.

Lee, Peter. *Sarong Kebaya: Peranakan Fashion in an Interconnected World, 1500 - 1950.* Singapore: Asian Civilisations Museum, 2014.

Majlis, Brigitte Khan, et al. *Batik from the Courts of Java and Sumatra*. Singapore: Periplus Editions, 2004.

van Hout, Itie, ed. *Batik - Drawn in Wax: 200 Years of Batik Art from Indonesia in the Tropenmuseum Collection*. Amsterdam: KIT Publishers, 2001.

Veldhuisen, Harmen C. *Batik Belanda - 1840-1940: Dutch Influence in Batik from Java History and Stories*. Jakarta: PT. Gaya Favorit Press, 1993.

The Collectors

Glenn Vinson is a retired lawyer and private investor who lived and worked in Hong Kong and Singapore for seven years through 1981. He is a graduate of Columbia University and Harvard Law School. He was a Commissioner of the Asian Art Museum of San Francisco, and Trustee of the Asian Art Museum Foundation for more than 20 years, and Treasurer for 17 years. He and Joan met in Singapore and were married in San Francisco in 1983. They have collected Indonesian Textiles as well as Chinese and Japanese ceramics and pottery since 1980.

Joan Ah See Lee Vinson was born and raised in Singapore and moved to San Francisco with Glenn in 1981. In 1994 she founded and then chaired for ten years the Opening Night Gala for the Arts of Pacific Asia Show, benefitting the Education Department at the Asian Art Museum, and raising more than $1 million for it. Tragically, within weeks after being honored by the Museum for her years of service and for this and other gifts through the years, Joan died of esophageal cancer in June, 2016, before this book could be completed. Nevertheless, a part of her love of art and for the Asian Art Museum lives on here.

Claire Vinson, Joan and Glenn's daughter, graduated from Scripps College with a BA in Art History. She lived in New York City for eight years where she completed her MA at New York University in Visual Arts Administration and worked in contemporary art galleries. She joined Glenn and Joan in collecting the Eastern Islands, Borneo and Sumba ikats shown here, and contributed to the text, photography and design of this book. Claire collects primarily contemporary Western and Japanese art.

In South Africa 2012

Acknowledgements

Mary Hunt Kahlenberg was the premier American dealer for Indonesian textiles for more than 30 years. Joan and I started studying and collecting Indonesian textiles in the late 1970's in Singapore, Jakarta and Bali. After several years back in the U.S., we happened to attend an academic seminar in Santa Fe, New Mexico, where we sought out Mary, whom we knew of from her earlier publications while Textile Curator at the Los Angeles County Museum of Art. Over the next 20 years, we visited Mary in Santa Fe, and she often visited San Francisco. From our first purchase of a Sumba *hinggi* in 1989, until our last purchase in 2011 of a Sumatran belt (or *dringin*), we spent many hours (even days, on one occasion in Santa Fe), looking and learning from Mary about Indonesian and Indian textiles. Despite those *ikat* acquisitions, our primary focus with Mary tended toward the striking batiks she found from time to time.

Rob Coffland, Mary's husband, while being an important dealer and collector of contemporary Japanese baskets, has continued in semi-retirement Mary's work in Indonesian textiles. From her stock and his own acquisitions on trips to Indonesia, Rob is the source of some of the Sumatran and many of the Eastern Islands textiles in this book. He has been very generous with his time and advice in helping us expand our collection in areas we had not previously known well.

Andy Ng was a dealer in Singapore with close family connections in Sumatra. We met him in 1991 when we returned to Singapore for a six-month stay. Andy focused on *palepais* and *tampans* (also known as *kroes*), as well as Indian double ikats (*patola*) made for the Indonesian market and collected in Sumatra. He is the source for the tampans and "100 Tiger" *patolu* in this collection.

Thomas Murray, the leading U.S. dealer today in tribal arts (both textiles and sculpture), has been particularly helpful in explaining the history, uses and designs of the textiles of Kalimantan, Sulawesi and Sumba, as well as finding several pieces for us now in this collection. Tom is also an expert in the theory and use of Carbon-14 dating of textiles and sculpture, and helped with the dating of some pieces Mary Kahlenberg had not already tested.

Tom encouraged us to assemble this book and introduced us to **Don Tuttle** who, over a period of several months in his studio, unrolled, rerolled, closely examined and photographed the textiles shown here. Don's technical expertise and artistic eye are evident.

George L. McWilliams, graphic designer, collector, photographer and designer of many books that closely examine the cultures he has encountered around the world, spent many hours editing and advising us on the preparation of the first edition of this book. George is a graduate of the California School of Fine Arts (now the San Francisco Art Institute), and for more than 30 years owned and directed a highly regarded graphic and advertising design firm in San Francisco. George has been a good friend for many years, and first suggested what became the first edition of this book during our visit to his Modesto ranch in 2012 while the Asian Art Museum of San Francisco was exhibiting some of our batiks. George's colleague, Loren Rohr, also a graphic designer and photographer, worked with us and assisted George throughout the editing and completion of the first edition of this book.

Natasha Reichle, Associate Director of Southeast Asian Art at the Asian Art Museum, organized the exhibition at the Museum of some of our batiks in 2012-2013. She provided good counsel to us as we moved through the process of organizing our collection in preparation for its donation to the Museum, and has continued the study of several of these pieces now in its collection. Her expert and thoughtful commentary has informed our additions to this second edition of our collection, sharpened and corrected our commentary and added substantially to our knowledge of these textiles.

Rosanne Chan, Director and Design Director of CA Design, who is a graduate of the PolyU School of Design, Hong Kong, and her staff provided invaluable advice and guidance in the layout, design and production of this book. CA is an important publisher of art books and was introduced to us by Tom Murray. CA's expertise, 40 years of experience, plus the long hours and focus of Rosanne, James Tong, Eunice Chan and Aaron Sun resulted in the look and feel of this book.

Many of the batiks in this collection were featured in an exhibition at The Asian Art Museum of San Francisco, entitled, "Batik: Spectacular Textiles of Java," November 23, 2012 – May 5, 2013. Additional textiles from the collection, primarily Indonesian Ikats, are included in the Museum's exhibition, "Weaving Stories," December 17, 2021 – May 13, 2022.

Author:	Glenn Vinson
Producer:	Claire Vinson
Photographer:	Don Tuttle
Design & Production:	CA Design
Project Director:	Rosanne Chan
Project Manager:	Eunice Chan
Design Director:	James Tong
Photo Colour Management:	CA Colour
Production Director:	Aaron Sun
Publisher:	CA Book Publishing, Hong Kong cabookpublishing.hk publishing@cagroup.com.hk
ISBN:	978-988-76089-1-2

Published in Hong Kong